Let this be a creative space for planning and play.

xoxo, Monica Lee

SMART CREATIVE WOMEN

www.ingramcontent.com/pod-product-compliance
Lightning Source LLC
Chambersburg PA
CBHW051817170526
45167CB00005B/2057